NORMAN BISSELL became principal teacher of history at
Braidhurst High School in Motherwell after obtaining an MA
(Honours) degree in philosophy and history from the
University of Glasgow and is a former Area Officer of the
Educational Institute of Scotland. His interest in the need for
radical cultural renewal prompted him to found and lead the
Open World Poetics group from 1989 until 1999 and to
become director of the Scottish Centre for Geopoetics from
2002 onwards. His poems, essays and reviews have been
widely published and he was awarded a commission to write
a feature film screenplay in 2012 and a Creative Scotland
artist's bursary to research and write a novel in 2014. *Slate,
Sea and Sky* is his first poetry collection.

OSCAR MARZAROLI set up his own photographic studio in
Glasgow in 1959 and no other photographer caught so well
the changing look and life of the city. Whilst making over 70
films for Ogam Films in the 1960s and 1970s, he continued
to photograph people and places throughout Scotland and
exhibitions of his work were hugely popular. Since his death
in 1988, he has been widely acknowledged as one of
Scotland's greatest photographers.

D1101050

Slate, Sea and Sky

A Journey from Glasgow
to the Isle of Luing

Poems by NORMAN BISSELL

Photographs by OSCAR MARZAROLI

Luath Press Limited

EDINBURGH

www.luath.co.uk

First published 2007
New Edition 2015

ISBN: 978-1-910021-98-9

The paper used in this book is acid-free, recyclable
and biodegradable. It is made from low chlorine pulps
produced in a low energy, low emission manner from
renewable forests.

The publisher acknowledges the support of

ALBA | CHRUTHACHAIL

towards the publication of this volume.

Printed and bound by The Charlesworth Group, Wakefield
Designed by Tom Bee
Typeset in 10.5 Quadraat by 3btype.com

For May and Robert Bissell
who gave me a deep and lasting love
of the Argyll coast and
so much else.

Thanks

To Anne Marzaroli, Marie Clare Maccabe and Martin Macabe for their warm friendship, generous hospitality and support in offering to allow some of Oscar Marzaroli's photographs to accompany these poems. Their knowledge and good judgement was invaluable in our selection of these photographs.

To Catherine Lockerbie, Gerry Loose and Gordon Meade for their encouragement and assistance and to Gerrie Fellows for all her perceptive thoughts and sound advice.

To Gordon, Susan, Martin and Callum Bissell for being there for me, and to the people of Glasgow for their honest good humour and the people of Luing for welcoming me into their lives.

To the editors of the following magazines and books in which some of these poems first appeared: *Cencrastus, Circles and Lines, island, Luing Newsletter, Making Soup in a Storm (New Writing Scotland 24), The Dynamics of Balsa (New Writing Scotland 25), Open World* and *Scottish Book Collector.*

To Gavin MacDougall and all at Luath Press for publishing poetry books when most other publishers will not and for making such a good job of it.

Finally, to Birgit Whitmore for all the love and enthusiastic support she gave me at every stage of the making of this book.

Poems

SEA, WIND AND SLATE

Photographs

Introduction

These poems, written over a period of some twenty years, draw on my experience of life's journey in Glasgow, in several other places and on the Isle of Luing in Argyll. I was born and grew up in Glasgow and spent much of my life there, so it is natural that this is where my poems begin and that they reflect the city and its people in their varied, sometimes humorous guises. From city streets and parks the poems move out into different experiences of place and people such as the Kintyre of William McTaggart and the Edinburgh of Tony McManus, and into new mindspaces like the practice of Zen meditation.

However, my childhood holidays at the seaside, and in Dunoon and Kirn in particular, gave me a love of the coast that has never left me and nourished my desire to live by the sea one day. It took me years to find the right place, but I fell in love with Luing on my first visit to the island and took it as a good omen that day when I met David MacLennan, whom I knew through the Wildcat Theatre Company, and his wife Juliet Cadzow who came from Luing. I travelled round the Northwest Highlands and visited many other lovely islands in search of a special place, but the lure of Luing drew me back and I have lived here for over seven years now. These Luing poems were mostly written when I was still living in Glasgow and spending weekends and holidays on Luing. They speak of my love of the island and its ever-changing light, of dolphins and seals, the mocking laughter of gulls, and the solitude of a Celtic monk on Eileach an Naoimh.

I came to Luing to write, and I have certainly written a lot

here since, but not the boatload of poems I expected. Instead I've written a feature film screenplay, the bones of a novel, and, along with other directors of the Isle of Luing Community Trust, successful £1.3m funding bids and interpretation panels about the natural and cultural heritage of the Argyll Islands for the Atlantic Islands Centre which opened here in Cullipool on the west coast of Luing in May 2015. My screenplay resulted from a successful application in 2011 to the Creative Scotland funded Incubator scheme and is still in development. Last year I was also awarded an artist's bursary by Creative Scotland to undertake research and professional development, and write my first novel based on the last years in the life of George Orwell on Jura and elsewhere. Now that my novel is underway and much of my voluntary work for the Trust is complete, I hope to get my head sufficiently in the right zone to write more poems. In the meantime, I've added some new ones towards the end of this paperback edition, including a poem that won an *Oban Times* competition for free satellite broadband for the Trust.

I've always loved the work of Oscar Marzaroli since I first saw an exhibition of his photographs in the Third Eye Centre in Glasgow back in the 1980s. He had a remarkable ability to capture the changing face of the city and its people with empathy and, indeed, love, a love which extended to the Highlands and Islands on his many filmmaking travels. So I was delighted when his widow Anne Marzaroli offered me some of his photographs, including some previously unpublished, to accompany my poems, and I enjoyed selecting them from the vast Marzaroli archive with Anne, her daughter Marie-

Claire Maccabe and son-in-law Martin Maccabe. When I told Anne that a new edition of our book was to be published, she too was delighted. I'm only sorry that she did not live to see it in print.

The first hardback edition sold out and is now something of a collector's item. Its publication received national press and radio coverage and led to invitations to me to give readings and talks at Aye Write!, Celtic Connections, the Belladrum Festival and the Edinburgh International Book Festival, and to lead poetry workshops in schools, thanks to Live Literature Funding from the Scottish Book Trust. It also generated many interesting collaborations with other artists. The composer and musician Mark Sheridan wrote his *Atlantic Islands Suite* in response to a selection of my poems which premiered at the Atlantic Islands Festival on Luing in 2009 and featured Gaelic singer Margaret Bennett, fiddlers Aidan O'Rourke and Lori Watson, and maestro Mark on keyboard and slate percussion. Subsequently, Mark and I toured the Suite and part of his *Flight of the Arctic Tern* with Gaelic singer Mairi Macinnes to An Tobar on Mull, Seil Island Hall and the Argyllshire Gathering Halls in Oban as part of the Festival of the Sea, and later to the Moray Art Centre. Other collaborations followed including one with archaeologists, artists and the Tabula Rasa Dance Company at the Pier Arts Centre in Orkney, and last year the filmmaker Janey Devine made a lovely film of my prose poem Life is a Journey which can be viewed on Vimeo.

My most recent collaboration was with the Royal Scottish Geographical Society and the Friends of Hugh Miller in the form of poetry readings and a talk on the Isle of Eigg and in

Cromarty on the Black Isle in September 2014. This summer, the voyage of the Leader sailing ship around some of the Argyll Islands, including Luing, could lead to further trans-disciplinary collaborations. To paraphrase Oscar Marzaroli – who used to say he was 'waiting for the magic' before he took his pictures – the magic lives on.

Norman Bissell
Isle of Luing
June 2015

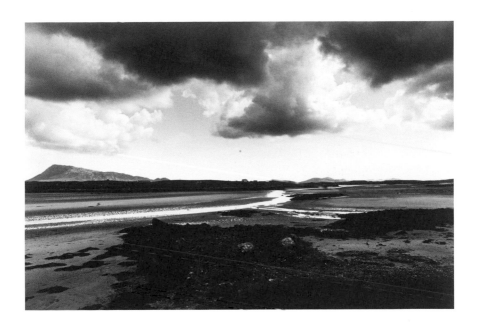

SLATE, SEA AND SKY

An island on the rim of the world
in that space between slate, sea and sky
where air and ocean currents
are plays of wild energy
and the light changes everything.

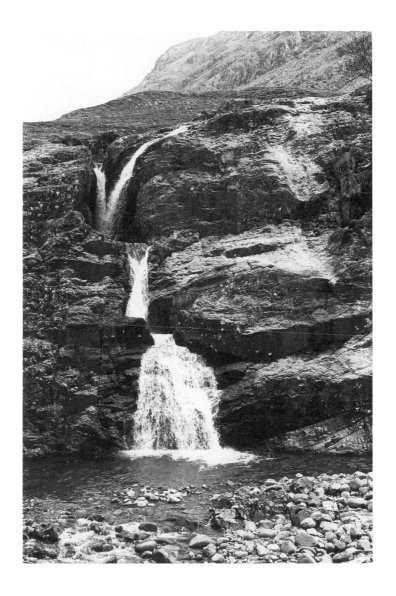

LIFE IS A JOURNEY

Life is a journey. The journey of a river. Its source lies un-
marked somewhere deep in the hills. A spring gathers itself
underground and emerges blinking into the world. It seeps its
way over boggy moorland, finds a gentle slope and begins to
trickle downhill, then merges with other springs and becomes
a burn chortling its way over small stones into dark pools.

From all sides come other burns to be lost in its flow; birch
and rowan and sweet blaeberries grow along its banks, tracing
blue veins on the hillside. It gathers pace as it falls into a
strath, scampering over boulders brought there by some long
gone glacier. Its surface glints in full sunlight. The strath
becomes a glen and more burns join it until it becomes a river.

Now it can take its time, for it has a sense of its own signif-
icance and, whatever happens, it has already come far. Other
rivers were not so fortunate, some petered out in lochans, but this
one flows on, picking its way over rocky ground, meandering
through wildflower meadows, sometimes losing its bearings,
doubling back on itself. It's in no hurry. Thick woods sur-
round it, villages appear alongside and people come to walk its
banks and admire its beauty. If it's lucky, another river will
flow into its waters, merge, then go its own way.

At some point on its journey the river will cross some
remarkable feature of the landscape, perhaps a wide valley or
confluence. There a town will sprout up and obscure its presence,
and folk will try to control and shape it to their own purpose.
Many will make a living from it, and some will pollute and
abuse it in all kinds of ways. No matter, it journeys on, renewing
itself and opening out as it nears its end. Its waters can no
longer be drunk since they taste of salt, it rises and falls with
the tides. Now it is a wide firth, a sparkling sea bounded only
by distant shores; gulls and oystercatchers dine out daily on its

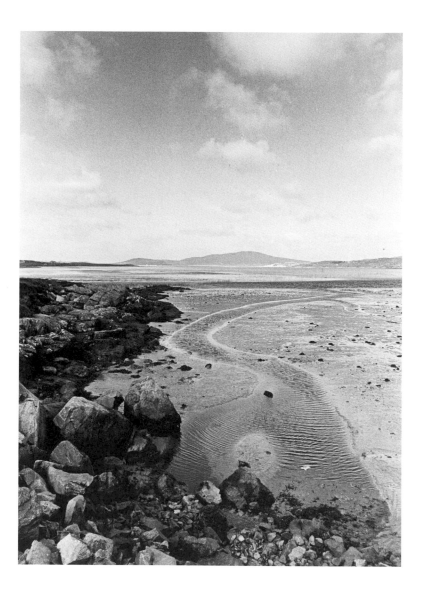

silt deposits. Out it flows into the ocean, bringing currents rich in nutrients which feed shifting shoals of silver fish.

The river has run its course, it joins with all the other waters which have gone before it to form the great oceans of the world. Eventually, somewhere far out at sea, perhaps some of its tiny particles may evaporate, form clouds, be wind-driven towards land, and fall as rain on the hills. The cycle of life has come full circle.

The self is a river. It derives from other selves, it grows slowly and is fed by many springs. In no two places on its journey is it the same. We give it a name and assume that it remains the same self throughout its life, but it is constantly changing. One day it will cease to be and will be lost to those who once knew it, yet somehow it may nourish others.

This book too is a journey. The journey of a man who begins his life in a city and finds humour in its daily rituals and beauty in the faces of its people, then moves out into different places and mind spaces where he learns how to forget the self, coming at last to an Atlantic island of slate, sea and sky where light and life are one.

STREET SOUNDS

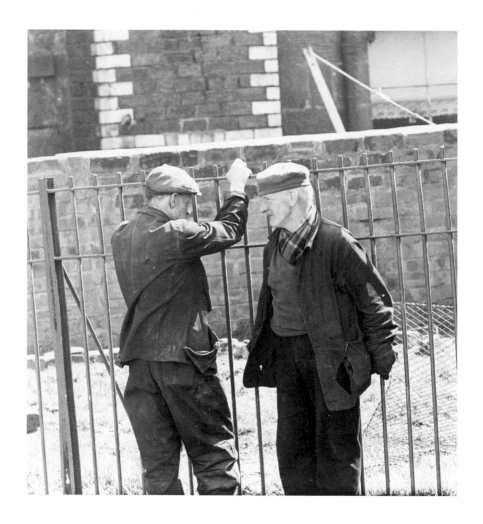

STREET SOUNDS

I long for silence
but no silence comes
day and night
cars and buses screech past my door
house music for the city dweller

Partick is in my bones
I lived up a close
which reeked of welding leathers
on men from the yards
who thronged Dumbarton Road

but the other day
at the corner of Peel Street
the noise of the traffic
and the builders' hammers
near drove me crazy

in the supermarket
it was no better
chimes and commands for checkout five
soon had me scurrying home
to empty my mind.

Still the question remains
how to find silence
in the midst of street sounds
how to empty the mind
in such a cluttered space?

ZEN AND THE ART OF SHAVING

Pshshsh white foam blob
splattered on dark stubble
scraaatch scraaape it off
hair by obdurate hair

don't forget the tricky bit
under your nose
head back
gumsy lips

sweet music eases the quiet
boredom of my daily ritual
staring blankly into
an empty mirror face

it should be possible
to contemplate the world
whilst plucking hairs
or at least the day ahead

shaving foam for sensitive skin
more like Chinese bloody torture
oh for the cheek
of a bum fluff kid

aw naw no the neck
red spots stain snow
I bury my blade
at wounded neck

Zen master say
better to grow a beard.

CALEDONIA BOOKS

On a damp afternoon its burning stove invites us in
through the gloom along tight crowded aisles
past an iron spiral going nowhere
a closed gate leads to a basement stowed with words

on shelf after shelf reaching for the ceiling
all those fat statesmen's lives nobody reads
ancient novels gathering dust
the slim lifeblood of poems undrunk

seeking Zen in the philosophy section
or with complementary medicine
I find it in a Black Sparrow tome
by Charles Bukowski

contemplating the sorry fate
of unread words torn from hearts
I jump on a bus home
and write some more.

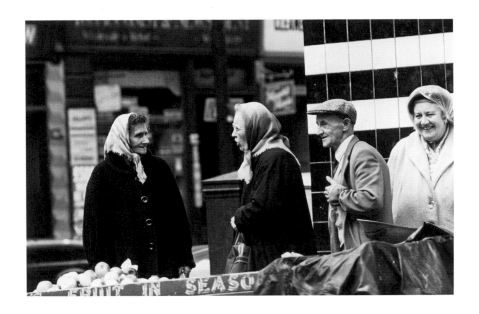

FACES

Faces in a bus queue ootside the bingo
faces of white-haired women
who've seen nothin but work
aw thur lives
suckin sweets

lined and wrinkled faces
perms tae match
cranin tae see if their number's up
whit number's that son
a cannae see a thing
withoot ma glasses

cheery faces
stuck in the intimations page
of the *Evening Times*
(lots more deaths than births)
aw the way tae Partick

ach it's the same thing every time
they cannae pass the garage
withoot stoapin
come oan son
some o us uv goat hames
tae go tae yi know.

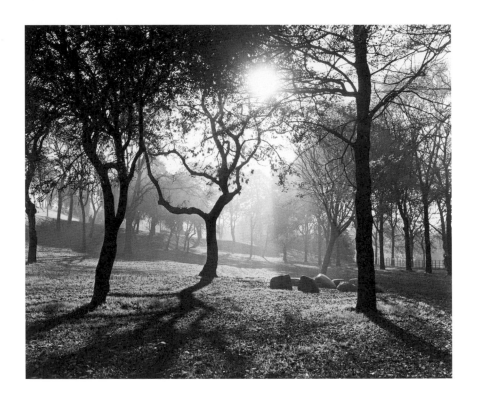

THE EARS HAVE IT

Sittin on the number 9 bus
on my way to the Writinfeist
sittin at the back I couldn't help but see
a man with the most enormous ears
the most enormous ears you have ever seen

thick and reddish purple they were those ears
spotted from the rear of the number 9 bus
thick and fleshy and soft enough
you felt with finger and thumb
you'd love to give them a really good tweak

huge pudgy malleable ears
ears you could chew on most happily
for many a happy hour
the left flap flapped even wider than the right
along Dumbarton Road, Balshagray
near translucent in the window light.

We got off at Partick Bridge
and flew upriver those ears and I
to Kelvingrove, looked down and peed
on Spalding from a great height
Julian not Gray I'm sure you know

we crossed over Kelvin Way
and alighted on the bandstand
much benighted to proclaim
wur 'ere because we're ears
an wur no movin
nae private ears 'ere!

It'll no be a strike or a work-in
thank the lord, it's a sit-in
'and there will be no bevvying'
aye thur will ya sell-out bastard
away an write yur lies fur the *Daily Scum*.

So on tae spires at Gilmorehill we sat
feelin much better fur maist o' that
aw eyes an ears fur the city
stretchin out afore us
where we had dreamed that one day
we'd flap up
 and away.
 fly

A SHELL BOX

In this room surrounded by books
and neighbours muttering
how I never visit them
all these learned friends
and their wise words
I never read.

In this room so much paper
words stacked up on words
so much driftwood dumped
by over-blown minds
just as well I planted
all those trees round the back.

In this room a shell box
an array of sea shells glued on
with green felt
for precious jewels
a gift from Friday nights
at the Life Boys.

In this room the accumulation
of a life piled up
waiting to be found
a life spent following
ancient tracks finding nothing
only now being.

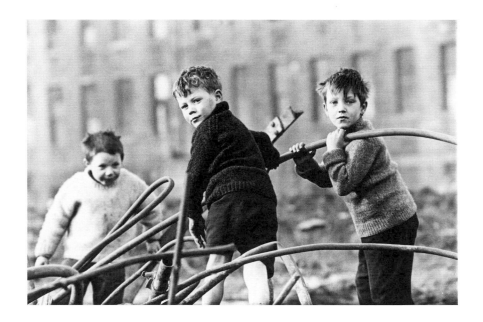

In this room time to examine
all that rushing around
doing good for others
pointless pointing
instead of looking
inside the box
at empty presence.

A PUBLIC SERVICE ANNOUNCEMENT

No one is trying to interfere with your inalienable
constitutional right to smoke as many fags as you want
no one is trying to prevent you
from enjoying yourself in a patently public place
or to persuade you of their
would-be supposed moral superiority.

No one is saying that because of tonight you or anybody else
is gonnae puff 'n snuff it tomorrow or the day after
no one is saying that you won't live
till you're 93 on twenty a day
or that you might not get run down
by a 62 bus on the way home.

No one is claiming that cigarette smoke
is the only poison we're all taking in
no one is claiming that fathers definitely
get cancer that way or that you might not
have to watch your mother die
slowly and painfully jist the same.

Everyone knows you've gottae expect a stuffed-up nose
runny eyes stinkin hair an clothes the next day
everyone knows that's the price to be paid
to listen to some words and music once a month
or to meet with folk you happen to like
or otherwise consider to be the salt of the tormented earth.

Everyone knows what it says on the packet
the hoarding the plastic bus shelter again and again and again
everyone knows that you have the godless given right
to take out another nail
and batter it into your coffin
or someone else's around you for that matter.

Everyone knows it's no easy tae kick the habit
no tae take the rough wi the silky smooth cuts
everyone knows about the urge the surge
of peace perfect peace in the midst o' the mayhem
an that yiv gottae be some kinduva Denis Leary masochist
jist tae put yer face roon the door.

All we are saying is that instead o' lightin up another one
jist take a few deep breaths for the next hour
all we are saying is give us some air
or even a wee bit of respect
for the person sittin next to you who can't stand it
but turns up anyway jist tae listen tae these poems.

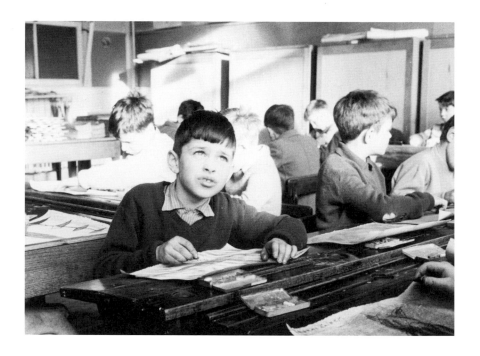

WHAT'S LEFT?

What's left after all
at the end of the day
after what seems
like a lifetime
teaching in the one place?

Only the seeds of ideas
the opening of minds
and the feeling
that human relations
between young and old
might still be possible
in spite of all the learning outcomes
the assessable elements
laid down from on high
which is to say as low
as you can go
without tying yourself
to the back of the heidie's car
on the way out of work
or even better from his point of view
on the way in.

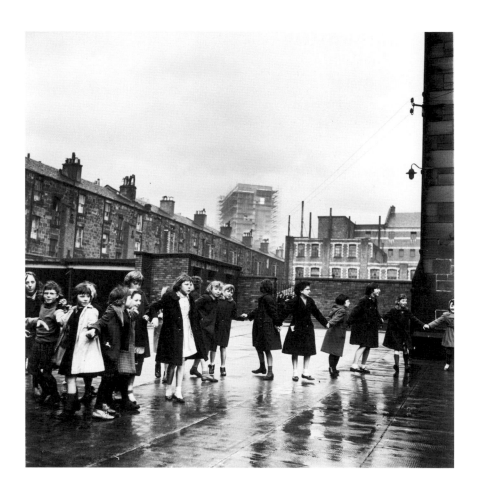

What's left after your friends
as well as those
you don't really know
have died as a direct result
of taking what they do
as seriously as the job deserves
not forgetting
those tender young shoots
already withering away
on account of the stale air
they breathe every day?

What's left of all those
who have gone before us?

They live only in the hearts
and minds of the young.

What's left?
Only the perpetual flow of life.

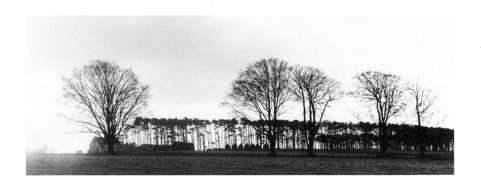

LEAVES FALLING QUIETLY FALLING

Leaves falling quietly falling
from great willow and ash
long green leaves
falling quietly falling

no wind stirs today
must be late morning frost
gnawing at their stems
leaves falling quietly falling

green brown golden heaps
piling up where they drop
beneath bare-armed branches
leaves falling quietly falling

mind drifting slowly
in and out of non-self
following the breath
leaves falling quietly falling

from Ruchill to Carntyne
Knightswood to Nitshill
this day all over the city
leaves falling quietly falling.

BOXING DAY

A dull December day
crows and gulls swoop and curl
outside my window
spare branches silhouetted
against a pale grey sky
a magpie flutters around preening itself
traffic sounds come and go
and the light slowly fades
red halogen turns orange
a dog barks somewhere
my bedroom lamp glows brighter.

Close reading making notes
letting my body uncork
after so much swishing about
slight aches and pains
some fingertip twinges
little corporal discomforts
while studying Nothing Special
by Charlotte Joko Beck
learning the non-meaning of life
till happily I slip away
into the land of sweet snooze.

There's only so much
living in the moment
a man can take.

INTO THE LIGHT

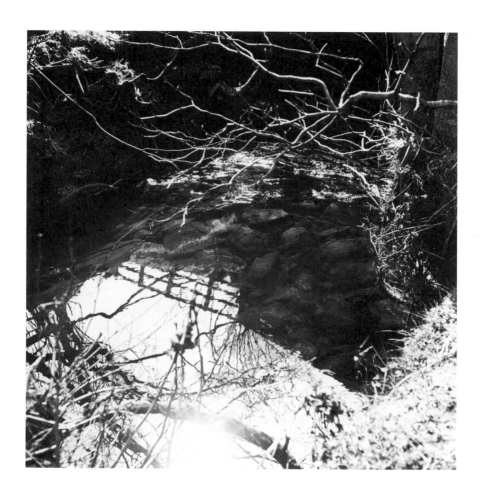

OPEN WORLD

open world
open to the world
open to explore world
open to new and old ways of looking at the world
open to experience world
open-minded towards world
open-ended world

listening to the wind
watching seasons change
tasting mango flesh
smell of moist leaves
touch of love

earth world
earth-rooted world
land rock plants trees air
sea rivers flowing insects birds soaring
cities live in landscape
world is more than human

a way
ways of approaching world
ways of living in the world
ways of expressing world
being aware of world
a wearing world

one world
one whole world
one whole outlook on world
many whole world outlooks
a sense of oneness with the world
one whole world
is
open

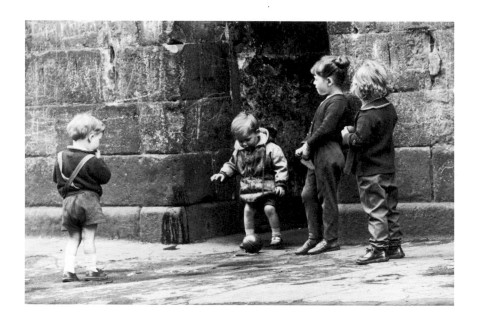

TO A WILD-FLOWERING WOMAN

There goes one o' the poor wee Murrays
nae mair poor nor wee
but strong and straight
as her loping stride up cobbled streets.

A voice and mind sharp and clear
as a spring morning on Berneray
tracing out the land with the same bright eye
of an old man in Assynt.

She gave her wean all the love she'd missed
in lonely rooms those small hands twisting papers
to set in cold black grates
no fires burn like hers.

She lives in a place
where others cannot reach
and only truth can grow
where else is there to be?

A wild-flowering woman
who welcomes foxes into her garden
and likes nothing better than to sit here
with green-growing life in bloom like her own.

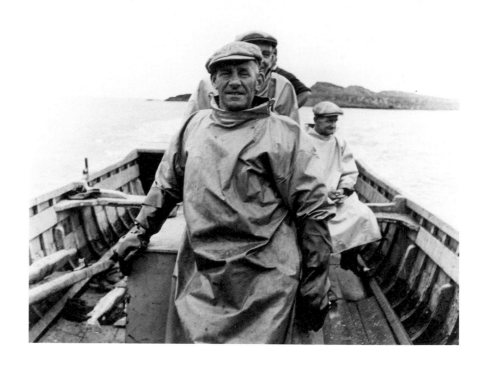

McTAGGART'S WAVE

He was aye drawn back to Kintyre
from his studio in the capital
Crail and Carnoustie were fine
but there was something about
west coast light and space
that made him see
with his child's eye again
gazing from sandy dunes
at white surf roaring in
hearing gulls yawping above him
in Bay Voyad
so each summer he took
his family back there
and thought nothing of spending
a whole day painting a single wave
returning home only when the light
and his eyes went
he couldn't explain to his wife
what he was after
he knew that this was a fish
that wouldn't be caught
but each day he had to
put to sea.

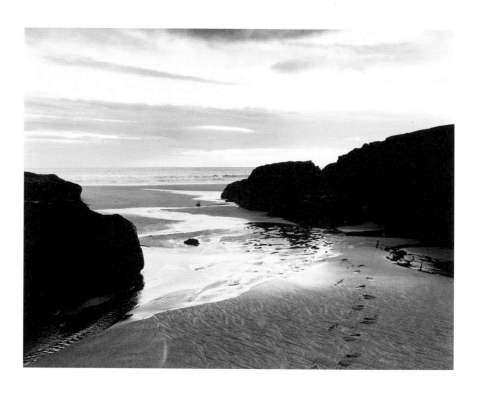

THE CAULD SHORE

The cauld shore
sound of the sea
white water breaking gently
on shingle and sand

a light blinking out there
in the dark
a shiver up my back
lost children calling

hot bubbling tar
cards and cribbage
an infant face following rain streams
down misted windows

a gospel service
held there on the beach
the voices of the dead
whispering in the wind.

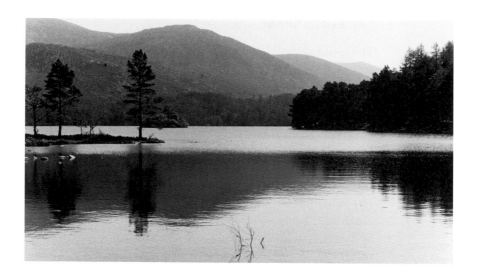

THINKING OF HIM NOW

Seeing him that last time
much thinner, frailer than before
we talked for hours
he listening intently
making his point with the hint of a smile
sometimes looking dreamily beyond
me talking nervously at times
not wanting it to end.

Then Nanon's voice on the phone
I've got some really bad news
Tony died this morning
and the feelings of guilt
at not having seen him those last weeks
as we all have when someone we love
is no longer there
where we want them to be.

Those next weeks learning so many things
I never knew about his life
the river of faces at Mortonhall
and meeting some of his family for the first time
reliving our walks together
under that big sky at Aberlady
the four of us
watching the light fade offshore.

Thinking of him now
all his quiet energy
that candid, knowing look
his clear voice in my head
insisting
better get on with the work
there's no time to waste.

BLUE SKY STILL PINES

Blue sky still pines
river snakes silvery blue
mud-brown cattle flicking tails
sheep dogs chase them home.

Passing hum of planes and flies
even cars seem quieter here
three friends on a winding road
poets scattered on lush grass.

The old lodge just sits peeling paint
its windows open
in golden sun of children's games
and uncanned butterfly laughter.

All summer I've wanted
a day such as this
to lie back
and do as little as humanly possible.

How can you capture all of this?
In words, snaps or film?

The truth is you can't
better to let it go
and flow through you
this bright September glow.

GLEN KIN

two grey granite setts
narrowing to the earth
Glen Kin

a row of old birch
sprouting lichen beards
a stillness here

at the foot of the burn
among the big pines
two white cottages

splayed red bracken
where midges gather
autumn's come

last year that hillside
ravaged and scarred
now green life returns

on a deep pool bottom
grey and brown shingle
crystal clear

high in warm breeze
a buzzard circles
and soars

 seven log stumps
 circle ashes
 silent traces

in still air
feathered birch leaves
start
 to
 fall

 roots torn from the earth
 logs peeling bark
 a red admiral sails

over the pinetops
a hoodie craw flaps
no sound

 a sea-blue pipe
 by the burn
 water supply

wisps of smoke
over the barn
steady drum beat

cutting carrots
stirring plums
metal on metal

a weathered silver shed
an orange roof
fading grass

brown and cream circles
of damp mushrooms
finger sinks in

at the end of the path
an old blue rowan
berries dripping red

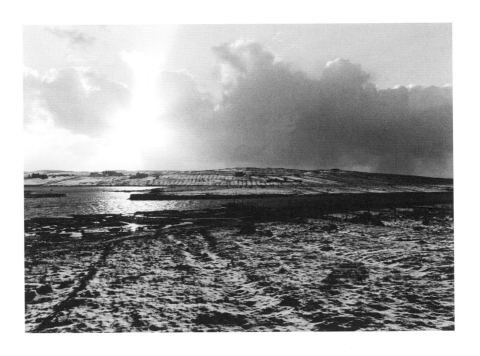

CLEAR GLINT OF LISMORE

Leaving Oban Bay at first light
mist drifting low over grey waters
steering north beyond Ganavan on the oily roll-on *Eigg*
the sun glowed pink on Cruachan's peak
and we knew the day would go well
until a bulging-eyed ferryman said
it was too misty to land today on Lismore
but soon the long isle between the mountains lay ahead
and we were winding along a white track
to the wee kirk of Moluag with the Good Shepherd
and a sower gleaming stained-glass down on varnished pews.

Heading over the hill
a woman burning tables told us
to follow the kye to the stream
where thick icicles hung from a hole in the wall
and a million frosted diamonds sparkled
like Christmas lights on virgin snow,
there Castle Coeffin sat squat guarding the shore
and we wondered at a silver heron
in raggedy winter coat so still on a rock
and thought even Glensanda's snowy-terraced superquarry
looked fine in bright sunlight.

We talked of Napoleon and geology on the way back
and took in Point and thon deep gorge
facing Port Ramsay's limestone row
before reliving Janice's freewheel down Achnacroish brae
to hot soup and sandwiches by a roaring fire
and a fine malt to warm the heart,
each of us keeping that clear glint
of sun on frosted snow deep inside
to remind us of that glorious day
at the end of the year on Lismore.

THE LAST TIME

Winter solstice
and in this big front room
seven just sitting
what else is there to do?

The bell rings all becomes clear
thoughts come and go
let them come and go
passing footsteps, fitbaw cries in the wind
slowly you come to accept
that you are that.

Walking slowly round the room
chanting the hannya shingyo
to the steady beat of the mokugyo
letting the world wash over us,
as we prepare breakfast in the kitchen
suddenly silently snow starts to fall.

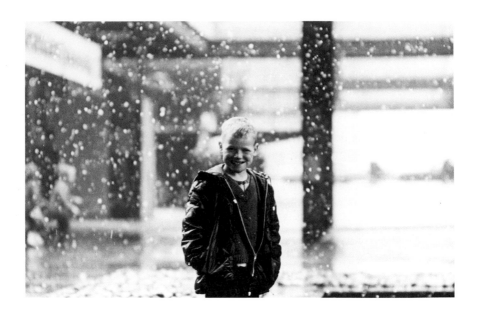

We stop and stand arm in arm
gazing out the window
lost in the whiteness
which shrouds the rooftops and the garden
we dance with the snowflakes
child eyes bright at their beauty.

A shiver down the back of my neck
a squeeze on my side
the moment over
we return to the big room
to sit for the last time.

To know the self
is to forget the self
we sit
and forget.

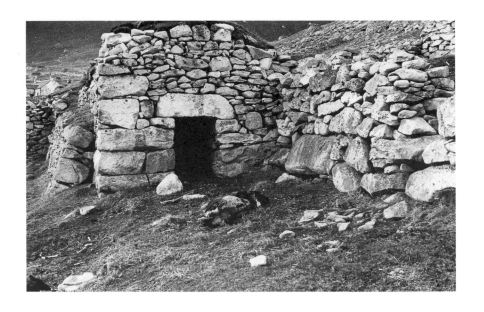

ALONE AGAIN

Alone again
after a weekend practising
with pain and concentration
sitting through the soreness
absorbing the sound of the wind
the cry of the gulls
exertion is awareness
alone again
with the aches
and the light.

SEA, WIND AND SLATE

SEA, WIND AND SLATE

Fierce gales hurl Atlantic breakers
right up the Firth of Lorn
to crash over Ormsa and Dubh Sgeir
and sweep on towards Luing's dark shores
each wave gathering all its strength
and with one enormous surge
pounding itself on black rocks
lifting great slivers of slate
casting them up on a raised beach
to explode in seething foam
a welter of white water
deafening in its release of wild energies
mustered five hundred miles out
in this great stormy
ocean of the world.

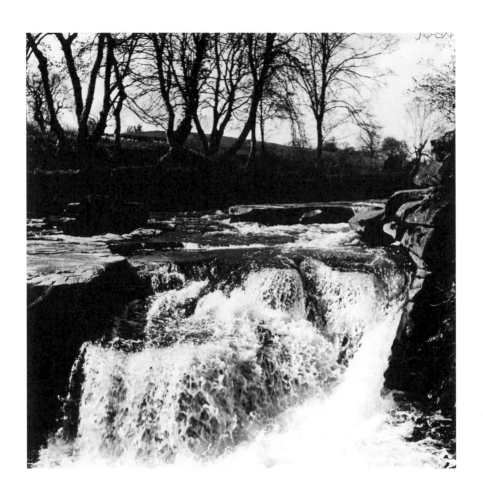

FOLLOWING THE RIVER'S FLOW

Following the river's flow
all the way north and west
setting off early January
sun low behind me
travelling the Great Western Road
where it shadows the Clyde
heading north when it splays out
just past Bowling fat buoys
marking sandbank shallows,
first buzz Glesga's Mount Fuji
running from ridge top rivers of snow
Ben Lomond from the Vale,
cutting through worn old pines
and further up the loch, larch and birch
framing snowy peaks dead ahead
past Inverbeg a glowing golden hillside
exposing grey rock gouged out
to suit hauliers and tourists
picking up the West Highland line
suddenly in the woods a silver viaduct
reflecting white flurry of loch waves,
the fiery redness of birch branch
burning in early morning sunlight
by the rushing Falls of Falloch
climbing now, those withered pines
last remnant of the forest of Caledon
clinging on by twisted roots
to that bare blown hillside
journeying on by Still Brae

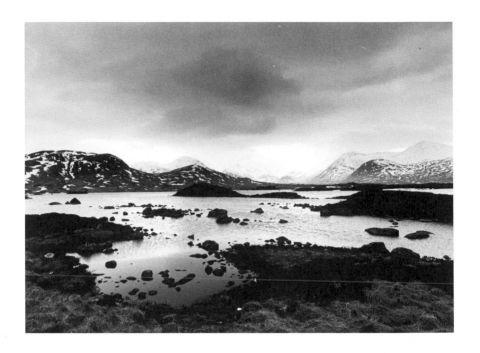

more great corries dripping snow
opening out all this space, and you know
this is the only place to be
this new year's morning,
following the river's flow
along white-pebbled Glen Lochy
wheeling down to Dalmally
awestruck by Cruachan in winter glory
flying past Highland Heritage hotels
for once no hanging baskets
wondering why I've never been to Stronmilchan
or gone steamboats on Loch Awe
tracing the lochside now on stilts
where dead navvies emptied hollow mountain
wearying now on this long road
that seems to go on forever, then
catching the glint of cold sunbeams on the loch
a glimpse of scree and rowan
growing right down to the edge
in the shifting Pass of Brander
following the river's flow to Conncl
where lone herons contemplate Lora Falls
spreading before me beyond the Brig
the western seaway to Mull and Lismore
trying not to get caught in Oban Bay
with the crowds and the clam boats
rushing on by Loch Feochan

a smirl of rain on the windscreen
turning on to single track at Kilninver
through Barnacarry open again
pausing only to watch a pair of swans
sail through Duachy's reeds
crossing humped-back clachan brig
by the Tigh an Truish
making sure I don't miss
the last little wood or the ferry
tacking its way across the seven knot
tidal race of Cuan Sound
enjoying the thought that I'm nearly there
on the green isle at last
winding my way up and over the hill
Rambling Rose at anchor in Torsa Bay
making west at Pillar Hill
first sight of Fladda blinking white
following the river's flow all the way
from Glesga to the Sound of Luing
following the river's flow
back home to the Atlantic sea.

TOAD KOAN

Ten thousand tiny toads
pour out of the quarry pool
hopping through gardens
across quiet roads
crawling up walls
and drainpipes into baths
always heading north
where are they going?

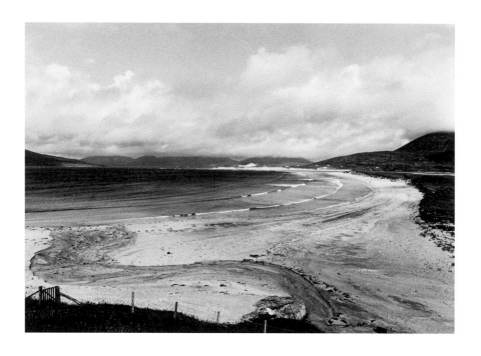

SOUNDS

Sometimes here
it's hard to tell
the sound of the wind
from the sound of the waves
or the sound of the waves
from the sound of the rain
or the sound of the wind
and the waves and the rain
from the sound of my breath.

A STOAT ONE MORNING

On the way to the Pillar one morning
I came across two stoats
cavorting on the road
above a crumbling stone wall
the smooth tan and white coat
and bright sharp face of one
staring at me, alert, inquisitive.

Nothing special she decided
and unhurried
disappeared under green bracken
only then did I feel
gentle spits of rain
fall on me and the road
and spot swallows
sky-diving above the hill.

In that moment the stoat,
the rain, the swallows and I
were one.

THE DAY CAME ALIVE

The day came alive
when they overtook our hurtling bikes
rising and plunging dark-finned
out in the grey-blue firth
six of them heading north
to the bay at Port Mary
where first one then another
jumped ten feet in the air
in exultant cetacean delight.

We rushed to Cuan Sound
to see them race a trawler,
dive at its bow with the current
and play in the shallows
to wait for the ferry to cross
with folk dangling over the side
and the ferrymen joining in
then swim back and forth
in sheer exhilaration.

That night we made love
with the exuberance of dolphins.

WIND AND WATER

This day steady drizzle
fills potholes and puddles
runs off shiny grey roofs
slithers down ronepipes
plops into stanks and pools
drips down the back of your neck

the green quarry pool quietly fills
gulls sail through smir
their big languid wings
alight on circled ripples
a wild westerly's getting up
we coorie in tighter round spitting fires

'you have to go with the weather here' says Iain
'but what more could you want than this?
some folk go on about the winter
about the rain and the wind and the cold
but I like it fine here in the winter
this'll do me

do you think you'll ever live here?'
'oh I'm sure I will one day' says I
'these houses deserve to be lived in'
'so they do so they do, you're right
these houses deserve to be lived in
right enough'

good feng-shui.

BLACKMILL BAY

You always find gulls at Blackmill Bay
often oystercatchers sometimes swans
or flights of darting wheatears on grey sand
they couldn't care less about the grand view
of Scarba, Lunga and the Grey Dog
it's what the tide and the burn bring
they've come for.

Helen has watched them over the years
from the big house at Ardlarach
she's brought up her children here
and seen the pier quietly fading away
so many changes she's seen
yet none to compare with the way the light
on Scarba changes in a single day.

BLUE LIGHT

She's been out there
in all weathers for weeks now
perched above the shore on big slates
thrown up by winter storms
set up odd-angled on village corners
squinting at trestles and easels
leaning into the work
prancing back and forth
a heron on one leg
blonde hair laughing in the wind.

What's she trying to do
bright eyes ablaze
and such lightness of touch?

Just catch blue light
between the tips of her fingers
let form dance
on the fine hairs of her brow.

She makes it look easy.

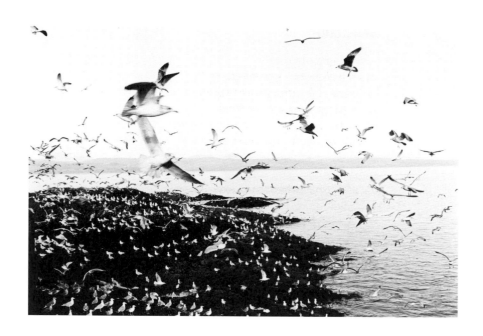

A DEAD GULL

A dead gull
came calling to my back door
and landed by the dry slate dyke
smooth grey back
black tail feathers
snowy wing tips, no head

a sky cruiser
riding cliff thermals
who glides and sails
and with a flick of her long wings
tacks and turns fast
into the wind

a sea diver in shifting seas
now still among the hollyhocks
garrotted by telephone wires
she fell to earth
swollen carrion for bluebottles
a dementia of rotting feathers

ignominiously in a poly bag
I take her up the hill
and return her to the land
of soaring gulls.

LICHEN CIRCLES

Alone in this bay near Port Mary
only the waves creeping in
and the squeal of a buzzard
high on a clifftop for company
even hotter than yesterday
less wind, sea less frantic
I lie here on this shingle beach
in the early evening sun
until the sea laps my ankles
and the sun's shadows grow long
around me sea pinks on wizened rock
terns diving out by the reef
three hours I've lain here now
among the glistening wet pebbles
and the lime green lichen circles
sky blue all blue
and a heat haze
right along the coast of Mull
drifting with the haze taking it all in
becoming those lichen circles.

CULLIPOOL BAY

Fading light over Mull
deep clouds drifting east
lipping waters
on grey footprints
haar seeps into the bones

I prowl the shore
lifting a stone here
some driftwood there
in the half light
sheep chomp through silent streets

light almost gone
grey rocks turn black
troubled mind soothed
by windless waves
wide bay just is.

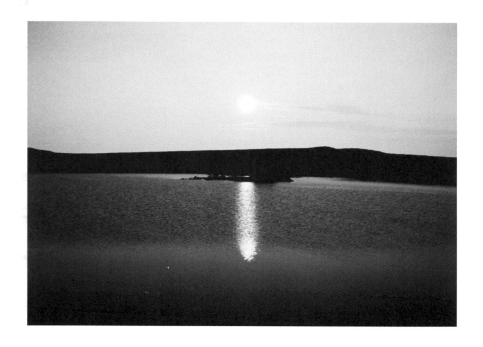

LONE SEAL TRAVELLING SOUTH

It was the kind of night when midges flitted
all ways in the windless night air
their wings transparent in golden sunlight
and sparrows whirred softly past
as you sat at your front door,
a lazy quietness taking hold of the place
and the village at peace with itself.
On such a night I took myself off to the shore
to catch another luminous sunset over Mull
and as I sat overlooking the calmest of calm bays
a lone seal came following the coast at dusk
travelling south along the Luing shore
every so often leaping out of the water
ducking down and with a flip disappearing
deep into that liquid world of fish and clams
and all that seals dream of
to emerge further south along the coast
moving ever closer to the Ponds
where the big seals hole up on Glas Eilean,
and it was then I took to thinking
of that playful journey home
that we all make alone in the end
wandering the coast leaving no trace
but the lapping of waves on shore.

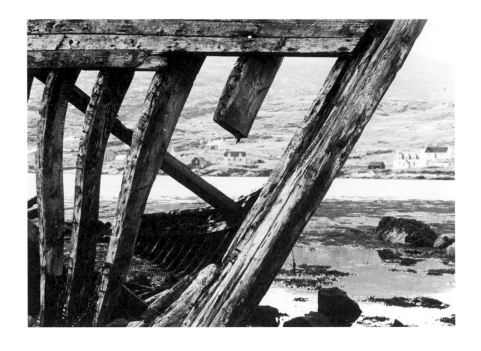

TO TAKE A BOAT OUT

To take a boat out
one summer's day
would be fine
and to hear again
the creak of oars
in their rowlocks
their feathered dip
in the sea
would be even finer
and out in the firth
to ship the oars
and lie back
and listen
to the chortle of water
under varnished oak
would be finer still
and to let the boat
drift with the current
wherever it might go
that warm blue day
no words can say.

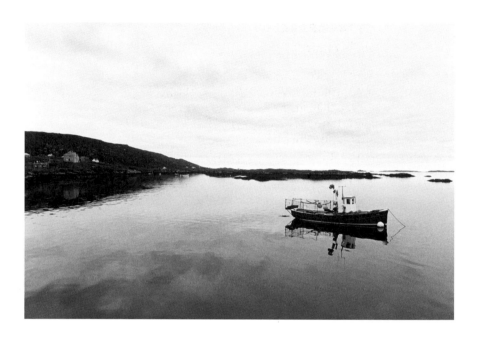

ISLAND CRUISES
apply within

Sure I'll take you out
but I won't go where I don't want to go
maybe that sounds a wee bit strange to you
but I'm not as quick as I used to be
if anything goes wrong
not that I'm saying it would you understand
you just never know
what it will be like out there
but call by some day and we'll see
maybe we'll go
and maybe we won't
it all depends.

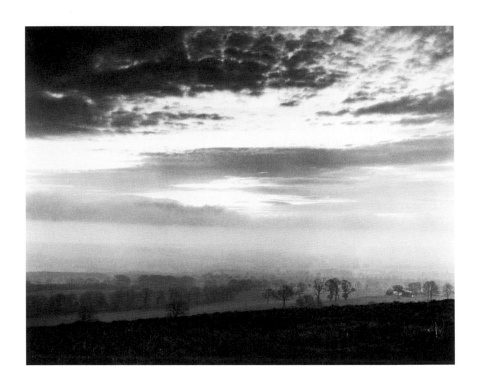

A MACKEREL SKY

for Birgit

Back then they too
sat on this beach
and watched the falling sun
they left their dun
high above the bay
and came here
with thin beakers
to sup and to marvel
at the energy of crashing waves
the steady flow of tides
forever turning
and at the sky
a mackerel sky
the fishermen call it
ribbed clouds stretching south
gold fading to bloody red
slowly dimming to grey
and the blueness behind
steadily turning silver,
of course they came here
they had fewer distractions
and were part of
these waves
and this sky
as are we.

SLATE

In this light slate appears dull
even ugly from a distance
when passing a quarry
raw rock gouged out
cliff face stretch marks
on closer inspection
gnarls and whorls exposed
in all their beauty by clumsy scratchings
are softened by sea spurge
thrift and marran grass.

After rain great flagstones of slate
carved and coaxed into gardens
gleam and shine
grey diamonds waiting
for this moment to explode
into sparkling brilliance
black silver polished by relentless tides
glowing and blazing
from darkest fathoms.

In full sun slate seems
flat sameness on a shore
unless fool's gold winks
a pyrite's eye from smooth slab
and a myriad of textures
colours and forms
fashioned by wind and wave
are revealed to those
who open themselves
to all its slateness.

NA H'IN BAN

Long hours he would sit in his cell
with the wind howling around him
enclosed by the walls he had built
tapering into the centre
the only light from two slatted holes
beamed into his blank space
his calloused hands told him
how thick those walls were
but he preferred it here
to the company of the other monks.

He had left the old land and the fishing
to get away from the distractions of others
and here on this rocky outpost
of the white martyrdom
he would not be changing his ways now
he still fished and farmed in order to live
and he would pray and sing with the rest of them
but most of his time was spent here in solitude
contemplating life and death
or up there on the ridge
with the gulls wheeling and crying above him
peering over that sheer drop
at the big surf
that came crashing in from the west.

This is what he had come for
just to be here
alone on a rugged isle
to live under that wide open sky
to watch the stars at night
and wonder at their wanderings
to be with all of this
and of all of this
is what he had come for
to this spare isle of the sea.

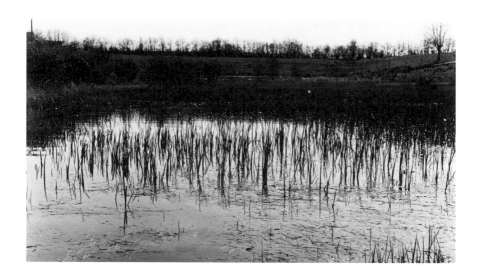

READING RYOKAN IN THE RAIN

Reading Ryokan in the rain
a sad old man living halfway up a mountain
who wandered far then stayed put
and travelled further.

He wasn't after anything up there
content with his own company
he delighted in simple things
snow on the pines, writing poems.

Sure now and again he'd go down
and play with the kids all day
and drink sake with the boys
he was a monk after all

but mostly he liked just sitting
letting all of life flow through him
listening to the rain, watching the moon
reading old scrolls under a flickering lamp.

Ryokan means good-hearted
and you can see why
he's the guy who cut holes in his veranda
to let bamboo shoots grow tall.

He found love late in life
or maybe Teishin found him
it was her love that made sure
that he journeyed on.

In his poems you can touch Gogo-an
it's all so clear and crisp
you can hear the leaves fall around him
taste his salt tears.

At night he feels lonely
up there on his own
next day spring is fresh and green
this is all there is.

What is it about him that affects us so?
one robe one bowl
the simplicity of a life
pared down to the bone.

Now here I sit
listening to the sound of wind and sea
knowing his is the way
to drink deep of the water of life.

HIGH UP THERE

Just as dusk comes
you hear them calling
before you see them
there they are
high up against a cobalt sky
thirty or more winter gulls
flying high in loose formation
kyow-yow-yow, kyow-yow-yow
kee-ar-ar-ar, kee-ar-ar-ar
kyow-yow-yow, kyow-yow-yow
high above those tiny dots
in the white-walled village
way below them.

They fly on and then come
six more straggling squadrons
the air thick with their wings
heading west always west,
where do they go
each night as the light fades?
Somewhere right down there
by the big cliffs
overlooking Carsaig Bay,
only a deep red glow now
beyond Garbh Eileach
alone with the rush
of dark waters on slate shore.

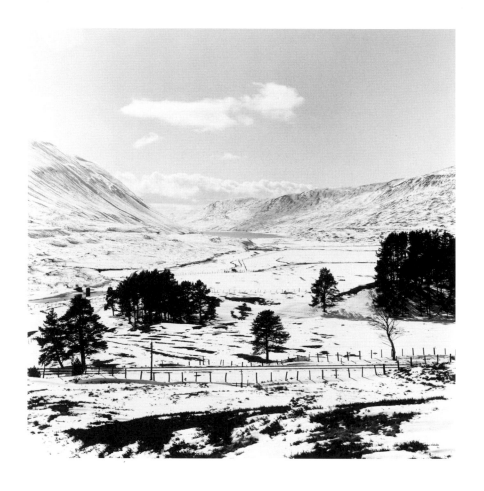

SILVER JOURNEY

Fiery birch along the lochside
silver icicles crack open rock
snowy mountains in a sea of blue
minus four at Tyndrum

a kaleidoscope of frosted grass
tall reeds frozen stiff by glazed rivers
listening to the speed
of the sound of loneliness

and when we got to the island
a young heron in winter plumage
stock still in a ditch
by the side of the road.

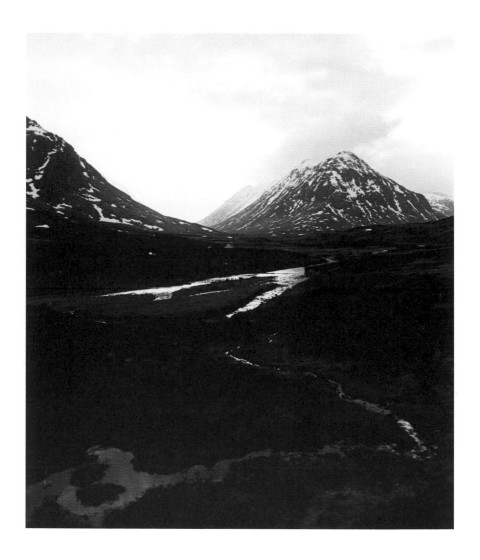

ON SUCH A WINTER'S NIGHT

Snow swirling on graveyards
softly falling on huddled stones
on the living and the dead
the cold eats at their bones
on such a winter's night.

What to think of this striving
for so many spiritual ways
and what we cannot hold
beyond these darkening days
on such a winter's night?

Even stone turns to sand
with the touch of ocean
and these hills are worn down
by the work of grey wind
on such a winter's night.

Why not accept the truth
of our living and dying
of the hills, sand and stone
where fine snow is lying
on such a winter's night?

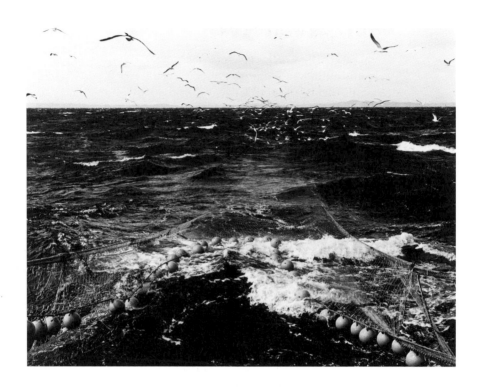

LATE DECEMBER ON LUING

greylag geese in wide formation
against a silvery sky
crossing the Sound of Luing
heading for Ardfern

a shag dips its head underwater
and with a leap
dives for the bottom
leaving no trace

a herring gull rides the wind
alert, unfettered
driven by the single-minded search
for its next meal

a red fishing boat returns
its catchful of gulls
trailing white across Shuna Sound
in late December light

all day hoodie craws keraak keraak
over grey slate dykes
tonight only the shoom and shiver
of the wind at my door.

WHEN YOU GO OUT

When you go out into the world
try to use all your senses
touch and taste wild thyme
smell hawthorn and kelp
watch herring gulls soar
listen to the sound of the sea

above all open your mind
and who knows
what you will find.

A GREENFINCH CAME TO CALL TODAY

A greenfinch came to call today
perched for an instant on the wire
and turning round, he's off.

It's been wet and misty much of the day
drying out and warming up, changing fast
only prospecting in the garden for now
it's all too damp.

A day for getting on with the work
tapping out letters on a screen
for thinking about life
where it's going to where it's been

but not for too long
got to live in the present
jotting down thoughts
feeling out words
trying to express the inexpressible

mostly just staring out the window
figuring out what's possible
and watching the day change
Scarba come and go in the mist
tall grasses shiver in the wind

Nothing special happens here
coming to accept that
getting in tune with it
that's the trick

– see the greenfinch has returned.

A SHOWCASE TO THE WORLD

A satellite to open our isle to the world
for a Trust with a story to tell
of slate dressing and fishing,
wildlife and wild ceilidhs
in the Atlantic Islands Centre on Luing
to showcase all the Argyll Islands
from Islay to Tiree and Gigha to Iona.

This line-free superfast broadband
with no trees to fall on poles
is all that Luinneachs yearn for
in their winter beds at night
with the wind wailing outside
to take the Centre around the globe
and bring the planet to our doorstep.

What greater need than this
that links this wave-dashed isle
on the edge with sierras and lagoons,
teeming cities and Arctic wastes
and with the people who dwell there
and want news of this bold venture
so dear to our hearts?

This is our call to Avonline
our fondest wish and desire,
a need to match the ambition
of our vision, and bring the people
of the world together
in this Atlantic outpost
for the benefit of all.

WINTER HAIKU

A blue moon
at the end of the year
portent of a million
points of light.

A fresh beginning
four days
four walks
in crisp winter light.

Ice drips on rock
the island freezes over
we chase the wild geese.

There are no skies
like winter skies
over the islands.

Snow on sand
ice on rock
a birth day.

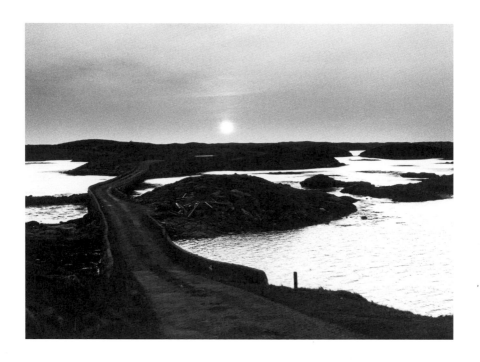

THESE SEA-WORN ROCKS

These sea-worn rocks will be here long after me
and you will see them with my eyes
these black wet rocks will remain
when we are long gone
we see them with the eyes of those
who beached their curraghs on this bay
and sheltered under these cliffs
and those who unlocked slate
to make roofs and walls
tonight we gaze in wonder
at the ceaseless rush of sea on shore
and you will think of us this night.